SACRED & PROFANE

JAMES LAWSON

SACRED & PROFANE
CALUM COLVIN

EDINBURGH

NATIONAL GALLERIES OF SCOTLAND

MCMXCVIII

Published by the Trustees
of the National Galleries of Scotland
for the exhibition *Sacred & Profane · Calum Colvin*
held at the Scottish National Gallery of Modern Art
Edinburgh, 25 April – 28 June 1998
© Trustees of the National Galleries of Scotland
ISBN 0 903598 82 5

Designed and typeset in Galliard and Mantinia by Dalrymple
Printed by BAS Printers, Over Wallop

Front cover: *Venus Anadyomene after Titian*, 1998
Calum Colvin

CONTENTS

PREFACE

The Scottish National Gallery of Modern Art first showed the work of Calum Colvin in the exhibition *The Vigorous Imagination* in 1987. The photographs were based on famous Old Master paintings, by Ingres in particular. Since that time Colvin has refined and extended his techniques and themes to include computer-manipulated and eschatological imagery. However, for *Sacred and Profane* he has chosen to return to his original technique of painting onto specially-constructed three-dimensional sets which, when photographed from a certain perspective, creates the illusion of two-dimensional images.

Colvin's new photographs are based on some of the most famous works in the National Gallery of Scotland. His reinterpretations of these well-known paintings in the light of our common contemporary culture and of his own personal iconography will provide a new thought-provoking layer to the already rich seam of historical perspectives.

We would like to thank Fujifilm Professional; Fine Art Research, Duncan of Jordanstone, University of Dundee; Percy Thomas Partnership (Scotland); and B&S Visual Technologies for their support of this project.

This exhibition, although shown in the Gymnasium Gallery at the Scottish National Gallery of Modern Art, is a joint venture between that Gallery and the Scottish National Portrait Gallery. We are grateful to Julie Lawson, Assistant Curator of Photography, for organising the show. To the artist we owe special thanks.

TIMOTHY CLIFFORD
Director, National Galleries of Scotland

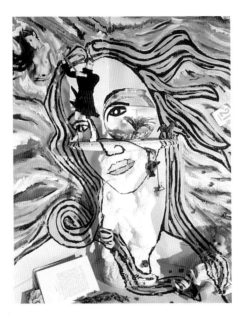

Fig.1 Calum Colvin
The Death of Venus, 1986

IMAGERY AND VISION IN THE WORK OF CALUM COLVIN

JAMES LAWSON

THE PHILISTINE – OR PERHAPS WITH LESS PREJUDICE he should be called the barbarian – walks through the ruins of a civilisation as he would past its relics in a museum or gallery, unaware that they might have meaning or relevance. Insofar as our own understanding of the works of our predecessors is incomplete – as it must be – there is something of barbarism in all of us. Yet we struggle to make what remedy we can of the condition. Where the Fine Art of the past is concerned, curators and art historians try to establish context and significance for works. It is an undertaking that is beset by difficulties; but they attempt to return works to cultural memory for the gallery visitor or the student of art.

However, it is not only for curators and historians to forestall the visitor who says dismissively, 'What is this to me?' It is also the artist who can give meaning and value back to works. Whilst the art-historical professionals reply that the answer is to be found in the past, the artist can show how works connect with present concerns. This is what Calum Colvin does in the images that comprise *Sacred and Profane*.

Colvin has chosen eight pieces which the National Galleries of Scotland have in their care, and conducts a meditation upon them. *Sacred and Profane* continues and expands an interest of long standing. He has treated the relationship of works hallowed in the history of art and modern life on previous occasions [fig.1]. Here, he is able to propose that the core concerns of Titian, Rubens, Elsheimer, Canova, Etty and David Scott remain affecting and challenging now. And he is able to

re-present these works to the modern observer in terms of an essential connectedness with personal and with broader political and cultural preoccupations.

In this, he re-enacts a procedure – if not necessarily with the same motivation – that artists have long adopted: he has claimed creative licence. Paintings and sculptures have not demanded of independent-minded observers and students a pharisaical deference to their brittle integrity. The greatest works have not been cast in stone, serving for subsequent generations of artists only to copy slavishly. Rather, the intelligent and imaginative student has assimilated his or her models, grasped their meaning and perhaps discovered their potentiality for being moulded to new purposes. We have a case to hand in the *Stoning of St Stephen* by Adam Elsheimer. The assassin whom Stephen half obscures, centre stage, has come to us out of Michelangelo's Libyan Sibyl in the Sistine Chapel [fig.2]. The turbaned figure to the left who also raises a stone may derive from the boy who tries to run away from the scene of the *Martyrdom of St Matthew* by Caravaggio in the Contarelli Chapel in S. Luigi dei Francesi, in Rome [fig.3]. Michelangelo's and Caravaggio's figures have not demanded obedience; and Elsheimer has even found different meanings for the poses. Artists have always had the prerogative of thinking about their precedents in a spirit of admiration, not of idolatry.

Colvin, the photographer, sculptor, painter, treats his models in similar fashion, as sources rather than authorities. But his method is novel and, involving all these media, creates images of great complexity. Indeed, it's not enough to list the media employed; it is also necessary to describe the work as installation, *objet trouvé*, even ready-made, for he has constructed domestic interiors and filled them with the junk, the furnishings and apparatus, of contemporary life. Upon these scenes he has painted selected elements of the images in the National

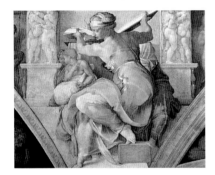

Fig.2 Michelangelo, *Libyan Sibyl* (Sistine Chapel, Rome)

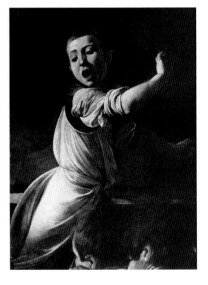

Fig.3 Caravaggio, *Martyrdom of St Matthew*, detail (Contarelli Chapel, S. Luigi dei Francesi, Rome)

Galleries. He then photographs the resulting superimposition or palimpsest of image and objects. Clearly, the procedure is elaborate and laborious.

The process can be described as going from set-building to photography. In fact, it is necessary to set the sequence also in the opposite order. Upon the domestic setting, the imagery, so it seems, is projected. The idea of projection – something quintessentially photographic, for photography is founded within the notion that light travels in straight lines – is crucial. The camera that, at the end, will receive the palimpsestical image acts as a sort of projector of the flat image. What Colvin actually does is set a drawing after the image in the back of his large-format camera and points it at his tableau. He can look through the back of the camera and see where his drawn image registers upon the furnished scene. He then plots the lines of the drawing into the three dimensions of the installation, after which he can paint the relevant surfaces within it. The result, from the point of view of the camera and the observer of Colvin's photographs, is a seamless image superimposed upon a real still life of domestic clutter.

The static point of view which the photograph insists upon, and the complete image that results, stand in dialectical opposition to the mobile perspective that the observer can conceive for himself. The observer who is not committed to the camera's point of view *conceives* the fragmented reality of the image and the tableau. It is a common, though always surprising, experience to have been convinced by a trick of illusionistic painting; that is, to grasp at the same time the illusion and the flat fact. Titian, three of whose works Colvin has selected to ponder, holds an important place in the history of illusionistic painting, as his illusion oscillates with the physical 'fact' of pigment. In the case of Colvin's work, the experience of holding the image and the reality simultaneously in mind is a sort of cubistic explosion.

The fact that Colvin's camera serves both as a projector of the image and a receptor of what we are calling the palimpsest intriguingly opens up for the observer an ancient question about the nature of vision. The sensation of looking at the photographs is one of occupying the position and function, at the same time, of a camera and of a projector. This simultaneous receiver and projector of images is an apparatus that is more complex than the eye, as we normally think of it. In the Middle Ages, it was a matter of serious debate whether seeing was a matter of what was called 'intromission' or 'extramission'. These terms correspond with reception and projection. On the one hand, the sense of sight was thought of as a process of reception of images given off by objects (intromission). On the other, it was proposed that the eye, conceived as a more active instrument, emitted a sort of beam of rational light, or geometry (extramission). Such a conception made sense to the medieval science of optics, which was largely an account of vision within the terms of Euclidian geometry. Modern optical science tells us that extramission does not happen. But psychology is less dogmatic on the point; and the history of painting in this century can largely be taken as a rejection of the modern scientific understanding.

When Colvin uses his camera as, in effect, a projector, he proposes an extramissive or, in more familiar terms, expressionist vision. The vision that is sent out by the observer is, in a crucial sense, imposed upon the world and is a product of the mind that originated it. The idea that the mind of the observer modifies that which it observes was stated with particular clarity by Picasso in one of the most historically significant paintings of the twentieth century, *Les demoiselles d'Avignon*, of 1907 [fig.4]. The distortions that the women in the picture undergo are to be accounted for as the action of the mind of their observer, originally a sailor returned from his travels to the brothel of the

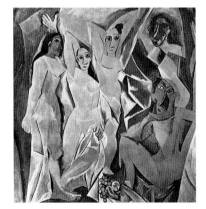

Fig.4 Pablo Picasso, *Les demoiselles d'Avignon* (Museum of Modern Art, New York) © Succession Picasso and DACS, London 1998

rue d'Avignon.[1] Having been perhaps to the South Seas, he sees the girls overlaid by his memory of distant encounters, and being a Spaniard he sees them as Iberian heads of the art of a remote time. In the National Galleries of Scotland, there is a picture that anticipates Picasso's projective vision, and Colvin's. Gauguin's *Vision after the Sermon*, of 1881, is also a work of prime art-historical significance [fig.5]. The 'vision' is that of the pious congregation which, emerged on feast-day from church, their imaginations filled with the priest's sermon on the theme of Jacob and the Angel, see the event acted out anew in the traditional wrestlers' games of Brittany. Vision is in the mind of the witness. Art colours the world for Colvin.

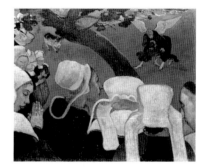

Fig.5 Paul Gauguin
The Vision after the Sermon, 1888
(National Gallery of Scotland)

Mundane reality and poetic imagining overlap in these pictures by Gauguin and Picasso and in the photographs of Colvin. In intromissive terms, the eye receives the image of a collision or entanglement of art and tat, of the Low and the High, in the photographs. When Colvin calls the work *Sacred and Profane*, he ackowledges this opposition, and at the same time proposes that their opposition is not irreconcilable.

It is a venerable artistic enterprise, to attempt to connect what is lofty in imagination and humble in life. Many artists have attempted the difficult task. On the one hand, there are the ideal types that have been developed in the visual and literary arts to act out dramas undistorted by topical and parochial detail. The National Galleries furnish an example in Gavin Hamilton's *Achilles Lamenting the Death of Patroclus* [fig.6]. But what is Hecuba to me? On the other hand, an art that is absorbed by the minutiae of the here-and-now clearly does not treat general issues, at least not ostensibly. Brouwer and Teniers do not present scenes of exemplary human conduct [fig.7].

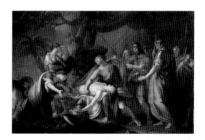

Fig.6 Gavin Hamilton, *Achilles Lamenting the Death of Patroclus* (National Gallery of Scotland)

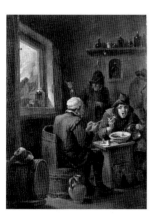

Fig.7 David Teniers Yr.,
Boors Drinking (National Gallery of Scotland)

The artist who perhaps epitomises the observer of 'low' subject-matter for the modern public is William Hogarth, the tercentenary of whose birth fell in 1997 – the year Colvin

began work on *Sacred and Profane*. However, Hogarth is better seen as an example to Colvin in a different task than the representation of what is low. In fact, Hogarth attempts to connect the high and the low, the general and the particular. Especially in his graphic work, Hogarth seems at first to be merely satirical, dealing with the England of his day. But closer study reveals that his concerns were also universal. For the compassionate witness, a whole civilisation is fallen, in the image of Tom Rakewell in the final scene of *The Rake's Progress* [fig.8].

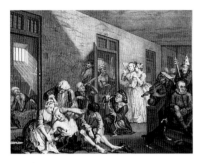

Fig.8 William Hogarth, *The Rake's Progress*, Plate 8 (National Gallery of Scotland)

Hogarth despised the piety of the critic, the obscurantism of the connoisseur and the mouthed invocations of the fashionable herd before art made sacred in the Salon. An art that connected, however, with the passions of ordinary human life could never be sacred in this phoney way: a sort of benign profanation was required, and Hogarth did that by forcing the local upon the universal, as Rembrandt had done before him. By that means, he believed, a true art replaced a false. The somewhat democratic argument that is implicit, to the effect that the moral and emotional life of the great is the same as that of the humble, is also present in the painting of David Wilkie, where, for example, the man whose property is being seized in lieu of rent experiences defeat on a Michelangelesque scale [fig.9].

Fig.9 David Wilkie, *Distraining for Rent*, 1815, detail (National Gallery of Scotland)

Colvin's action is similar to Hogarth's and Wilkie's. Rather as kitsch or gee-gaws from the antique shop will pollute the most elegant surroundings, high art is subverted by being cast into such tat-infested domestic interiors. Flame-effect electric fires, for all that they have the colours of a deacon's cope, jar against scenes of martyrdom; ironing boards have no place in the glade of a virgin goddess; and the hostess trolley should be conspicuous by its absence from the banquets of kings. However, this is not a subversion designed to display high art's emptiness. On the contrary, it is an intervention to save it from the

emptiness that the uncomprehending – the philistine – will pronounce upon it.

The art-historical way to make objects of figurative art alive and full of meaning is to seek out what were the premises of thought and sentiment at the time when they were made. Less scholarly perhaps, the museological approach might be to set works in time capsules – surrounded by what could be called 'cognate' artefacts. Then there is Colvin's method, which may be described as abstractionist or analytical. It turns its face away from the work of art as a thing of glamour and celebrity, and to that extent it is serious.

There are models in ancient piety for these approaches. Whilst the scholar presents a spare and venerable object whose essential remoteness will never be quite undone, the museologist intends something more evocative, a manifestation and a spectacle. At length, the artist/critic discovers the fundamental moral elements of the work, and presents them as having survived and as retaining their power to move us – to prompt us to rejoice with those who rejoice and lament with those who lament. Of course, these categories need not be exclusive. But in any event, the moral core having been established, the artist can weave these elements back into topical and local dramas. The power of venerable art to make resonant the modern scene was recognised with particular acuity by Edouard Manet. Surely it is Christ as Man of Sorrows who strikes a telling note in *Bar at the Folies Bergères*?

Pain, compassion, friendship, fear, denunciation, betrayal, hope, acquiescence: these are among the moral elements of the works that Colvin has chosen to treat in *Sacred and Profane*. It has demanded a close empathy on Colvin's part to have done so, for it is at the end of a journey, impelled by imagination and experience, of emotional identification with protagonists within the works, that the elements have been found. We make

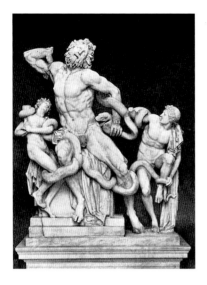

Fig.10 Agesander, Athenodorus and Polydorus of Rhodes. *The Laocoön*, c.125 BC (Vatican Museum, Rome)

some sort of sense of myth when we arrive at this core, for we identify there principles – things that persist through changing or evolving narratives.

The discovery of the emotional or moral core of the work of art was the task that Goethe set himself, when he contemplated *The Laocoön*, the work of Hellenistic sculpture around which has focussed so much discussion of ideality and expression in art [fig.10]. Goethe's action was also one of abstraction, or, we could say, of nominating the abstract value. So, he said, terror, pity and fear were evoked by the statue: the first by the plight of the father, the second by that of the older son and the last by the predicament of the younger son.[2] Artists sought to do the same thing. Both Etty and Scott set their thoughts about *The Laocoön* at the centre of their pictures *The Combat* (page 28) and *Philoctetes* (page 30). Etty, aiming to present the emotions in their purest form, presented his protagonists without the support of a text. He explained his purpose: 'My aim in all my great pictures has been to paint some great moral of the heart.'[3] In this, he did something similar to what Giambologna did in composing the statuary group of two men and a woman, that later came to be called *The Rape of the Sabine* [fig.11]. In the first instance Giambologna was telling no specific story: 'The subject was chosen to give scope to the knowledge and study of art.'[4] It is likely that he was provoked by critical consideration and discussion of *The Laocoön* to abstract emotions like this.

Nearly three hundred years later, Etty did the same. David Scott, like Etty, used Laocoön as his model. It was intelligent of him to recall the Trojan priest in the tale of a Greek warrior who, at the other end of the tale, was also attacked by a serpent. Or else, it was for the sake of expressing heroic suffering – a thing so lofty as to be abstract – that he went to critical writings about the treatment of emotion. Heinrich Winckelmann also wrote about Laocoön and noted the similarity of his suffering

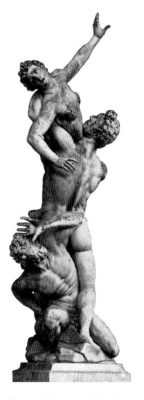

Fig.11 Giovanni da Bologna (Giambologna), *The Rape of the Sabine* (Loggia dei Lanzi, Florence)

to that of Philoctetes in Sophocles' play of that name.[5] It is this emotional or dramatic essence – something that endures the manipulation that his method involves – that Colvin places at the centre of his photographs. The three Graces are united in friendship – purified to the point of distillation; their ghost is present where the sick are cared for.

When Colvin superimposes the images upon the domestic tableaux, or, in the case of *The Three Graces* (page 26) a hospital setting, it is appropriate for him to edit the former. Where, in the original works, there was elaboration of characterisation or spectacle, he puts something simpler. The complication comes afterwards when he connects the art-image back into contemporary life. However, for all that, the observer begins at the same irreducible moral basis.

Upon the moral or mythic core of the individual works in the National Galleries Colvin lays down veils of narrative, meditation, argument and humorous digression, and, again after the manner of the palimpsest, creates a work of resonant thematic colour, always somehow transparent rather than obscuring, like the pigment of the Flemish Primitives.

Over his narratives is an autobiographical glaze. We are alerted to attempt to trace it in all eight images by Colvin's self-portrait presence in *The Feast of Herod* (page 34) and *The Stoning of St Stephen* (page 32), the two images which have sacred history as their theme. In the one case, the artist recoils in consternation from the consequences of a decision made. In the other, it is he who undergoes a martyrdom: the actual instrument, an object of Scottish kitsch; his sin, listening to a celestial voice calling him to the ascetic's place. The punishment is meted out by the parochial, who hate those whose vision extends beyond the local.

The thread of autobiography is started in these images and, as a result, the observer possesses it as one of the tools of inter-

pretation for the others. Thus, the presence of a record sleeve showing a couthy family group and entitled *Round at Calum's*, in Colvin's treatment of David Scott's *Philoctetes*, sets the event at least partly in the context of autobiography. Objects often stand in cubistic disjunction from one another – juxtaposed as well as superimposed – but we can, if we wish, assemble a theory about what this text says: the wounded and agonised warrior upon a dressing-table, from out of one of the drawers of which is disgorged a multitude of prophylactic or rubber gloves. Elsewhere in the series, the autobiographical thread is less prominent in the weave. For example, it is only familiarity with Colvin's earlier work, in which a kilted Action Man doll often figured as the artist's proxy, that enables us to recognise him in the role of Actæon when he comes upon Diana. It cannot be necessary to take this action man altogether seriously. Or rather, it is necessary to go along with Colvin and Hogarth again, and even Shakespeare, and say that the serious and the humorous do not exclude one another. That record sleeve in *Philoctetes* is a self-effacing Scottish joke. In *The Stoning of St Stephen*, the dead canary is taken up into heavenly glory, cage and all.

Another veil is political and cultural. Colvin has been interested in the Scottish national identity for a long time. In the present work, he notes the present historical moment. With the referendum vote of 1997, the decision is made; there will be a Scottish parliament. That, among other things, is the prospect that Colvin / Herod confronts in *The Feast of Herod*. Salome reveals John the Baptist's head, like the contents of an egg, perhaps a curate's one. Rubens' treatment of the subject serves as a good model for some of the emotions that accompany a change such as that which is impending. There is an appetite whetted; here is the promise delivered. Whether ghastly or as tasty as Herodias finds it, responses are ambivalent. A similar contrast

perhaps points to the same theme in Colvin's treatment of *The Stoning of St Stephen*, where the gruesome and the glorious (as in Elsheimer's picture) are both present. Assuredly, we will not have England to blame, and whether or not we make something of ourselves morally and culturally is our responsibility. The titles of the books scattered about Herod allude to the possibilities of true cultural ambition or a degraded appetite or one of sentimental fancy.

The idea of a quest in pursuit of an object merely of fantasy as a personal and a cultural error is presented in Colvin's treatment of *Diana and Actæon* (page 36). The hunter of Titian's painting has been transformed, as has been seen, into a Scotsman. The stag that he normally stalks is another cliché of Scottishness. Holman Hunt might have made Colvin's picture. His Hireling Shepherd had, a moment before the one shown, pursued a fantasy version of the Virgin Mary, dressed in white with halo of head scarf and lamb, only to find the whore of Babylon and receive from her the sign of death in the form of the Death's Head moth [fig.12]. Colvin's Scotsman make a similar mistake. He is engaged upon a sexual quest, his object a living substitute for Madonna: however, what he comes upon is not an accommodating and dedicated lover but the reality of domestic life – Diana conflated with an iron and an ironing-board. He retreats into clichéd Scottishness, represented by the litter of tat at the left-hand side of the picture. From the theme treated by Titian, we know to think that he is being consigned to a sort of cultural death, the spectacle of a Scotland for mere tourism, unimaginative and idle.

Colvin's *Diana and Actæon* is about the error of action in pursuit of fantasy. In Etty's *The Combat*, as Colvin presents it, a similar error seems to be present, and this time it is that of the female protagonist in the picture. Domestic business binds the victim and the woman pleading with the guitar-wielding victor.

Fig.12 William Holman Hunt, *The Hireling Shepherd* (City Art Galleries, Manchester)

Here, a yellow vacuum cleaner is the principal prop. In *Diana and Actæon*, Diana's black servant is replaced by a black vacuum cleaner. With woman and victor in *The Combat* emerging from a place of exotic flora at the left, the logical reading is that he has been conjured into existence by her as a rival of the victim. Here, the implication is that dissatisfaction with one's lot, with the social and emotional fracturing that results, is because of a misconstruction of cultural values. Again, the roots of tragedy as Hogarth conceives them are not very different. The Rake wanted to live a life out in the grand manner at the expense of the industry and probity that, for Hogarth, are its proper foundation.

Conception and misconception do not stand in conventional opposition in Colvin's *Sacred and Profane*. In fact the basis upon which we believe our eyes and our impulses is called into question in the terms of another theme that weaves thoughout the work. Photography, for all the possibilities of manipulation that are available, is what may be called an 'analogue' art. That is, there was a configuration of tones or colours in the world that, from a fixed position in space, could be impressed upon a photo-sensitive surface. Analogous with this notion is the idea of copying or parroting. It is a parrot-like thing that emerges before the consternated Herod. However, technology advances; an intermediary screen has now appeared between the camera and the world. It is the interface at which all the data that constitute primary visual experience is encoded or digitised. Because of that interface, the one-to-one relationship of image to reality loses probability.

Diana and Callisto (page 38) takes up the theme. Callisto is accused of betrayal by Diana. In Ovid's account – the basis of Titian's – a sexual encounter between Callisto and Jupiter was the cause of the virgin goddess's anger. Here, Callisto is conflated with a computer screen, which Diana, the old bellows

camera, construes as the instrument of misrepresentation and therefore of concealment and duplicity. In *Diana and Actæon*, Actæon, the hunter, is identified with the stalker or the *paparazzo*, the person who spies through key holes. He discredits the very faculty of vision.

In Colvin's *Feast of Herod*, with the uncovering of the charger, a roll of photographic negative is exposed and unwound, undone by light. It may be that soon we will not have the action of light upon photographic film to remember things by.

Reflection and the mirror – and with them photography – have been in peril. It has been suggested that Diana broke them in the scene with Actæon. At the end of *Sacred and Profane*, however, in an image of, it seems, fathomless complexity, the shards of fractured vision and belief in vision are reconstituted. It is always a question, whether the image is on the surface of the mirror, of the water, of the picture plane, or whether it is real, but ineluctably remote, behind the sacred surface of reflection. Colvin's *Venus Anadyomene* (page 40) has a reflection at its centre. In fact, it has two. First, there is the dressing-table mirror's reflection of Venus painted upon the left-hand wall (and therefore reversed) and assimilated to the Venus painted on the installation. Then, there is a camera set on a tripod in the pupil of her eye. The observed observes: it is impossible to say which is which, the camera to be seen in the picture or the camera that took the picture. Vision, as confirmation of the world, is no better attested than by a glance or a gaze returned.

Venus has been present in one of her guises or as an unseen mover of events throughout the series, *Sacred and Profane*. The Graces represented the parts of her benignity. Her compassionate and nearly human virtue had moved the woman in *The Combat*. Her profane nature had touched Salome, with tragic consequences. The Trojan War, and Philoctetes' agony, had proceeded from her charm and her gift to Paris of beauty, in the

form of Helen. Then, it was her principle that undermined Diana's chaste rule. In her first and final manifestation, in the picture from Titian's studio, at last she shows herself. In the mirror, her image is remote, like the bottom of a rock pool, but it is also immanent in the installation, and the remote and the immanent coincide. That has been Colvin's proposition: that myth and reality, art and life, the past and the present are not adrift from one another.

The fragility of memory is a peril to our civilisation and culture. What if our past should become meaningless and we should become blind to the art in our galleries? Colvin's *Sacred and Profane* argues that true memory is human feeling authenticated. Past and present are not essentially distinct when authenticity is the test.

NOTES

1. An accessible introduction to the medieval literature considering the question is given by James Ackerman in 'Alberti's Light', first published in *Studies in Late Medieval and Renaissance Painting in Honor of Millard Meiss*, ed. I. Lavin and J. Plummer (New York, New York University Press, 1978), pp.1–27; also published in *Distance Points: Essays in Theory and Renaissance Art and Architecture*, (Cambridge, Mass., M.I.T. Press, 1994), pp.59–96.

2. The sailor is included in preparatory drawings for the picture.

3. See M. Bieber, *Laocoön: The Influence of the Group since its Rediscovery* (Detroit, Wayne State University Press, 1967), p.27: 'The suffering of Laocoön excites terror, indeed, to the highest degree, while the situation of the dying son excites pity, and that of the elder son fear, yet at the same time hope for his escape.'

4. D. Farr, *William Etty* (London, Routledge & Kegan Paul, 1958), p.11.

5. See, *Giambologna (1529–1608): Sculptor to the Medici*, exhibition catalogue (Arts Council of Great Britain, London, 1978), p.15.

6. Bieber, op.cit., p.21.

SACRED & PROFANE

♠ I ♠

THE THREE GRACES

AFTER ANTONIO CANOVA

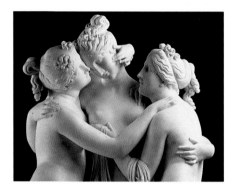

ANTONIO CANOVA 1757–1822
The Three Graces
Marble · 173 × 97.2 × 75cm · National Gallery of Scotland / Victoria & Albert Museum

The Graces are the companions of Venus. They are conventionally individualised as Aglaia, Euphrosyne and Thalia: Beauty, Gracefulness and Youth. However, their allegorical nature shifts with changing emphases within the character of Venus. Thus, Botticelli's famous Graces in the *Primavera* (Uffizi) are usually called Beauty, Chastity and Pleasure. Their action is described by the fifteenth-century art theorist Leon Battista Alberti, following Aristotle, as giving, receiving and rendering back. Together, the actions represent friendship. This conception of the Graces is consistent with the mythological proposition, of humankind, in the person of Paris, having chosen as its guiding principle, love instead of riches and power (Juno) or wisdom (Minerva).

Being touched in affection by more than one person is the essence of friendship, understood as a principle, and is the nub of Canova's conception of the group. The central figure touches her companions without favour and is like scales in balance. Her companion to the right receives the embrace. The Grace to the left makes the gesture that most animates the group. With her left hand – the most fragile passage of carving – she gently pushes the head of the central figure towards her, so that she can give back a kiss for the embrace. The group is not reducible to simple analysis because it is not three figures but, like that other Trinity, three in one. However, it perhaps also has an anti-type – another entwining involving three figures – *The Laocoön*.

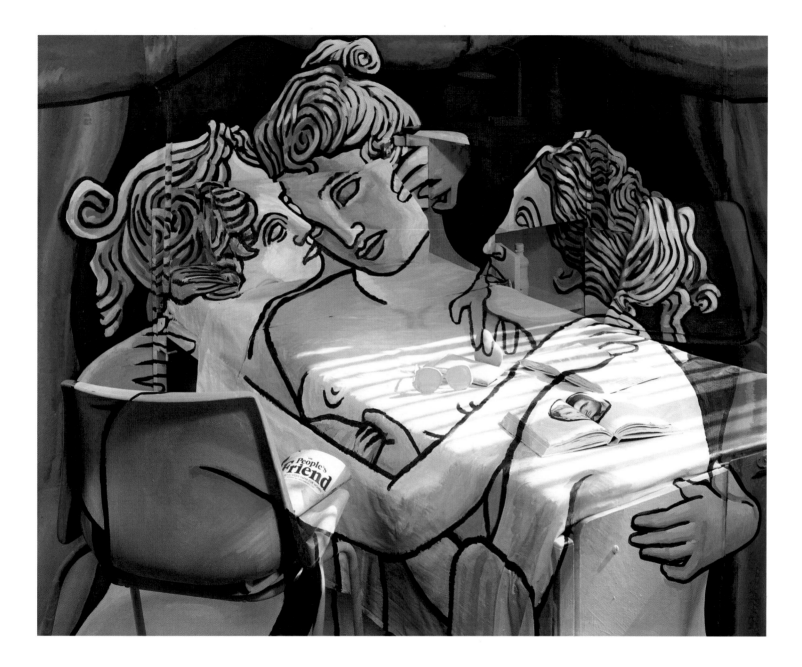

◆ 2 ◆
THE COMBAT: WOMEN PLEADING FOR THE VANQUISHED
AFTER WILLIAM ETTY

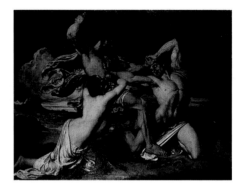

WILLIAM ETTY 1787–1849
The Combat: Woman Pleading for the Vanquished – An Ideal Group
Oil on canvas · 254 × 341cm · National Gallery of Scotland

The vanquished figure derives from the Hellenistic statue of Laocoön and his sons, which was discovered during excavations in Rome in 1506. From that time on, the work was much meditated upon and discussed by artists and critics. Here was evidence that human art could create the super-human – a matter of enormous philosophical significance – so long as there could be agreement that Laocoön's expression of suffering was both true and greater than that of which ordinary human beings were capable. Winckelmann, the famous historian and critic, pointed to the issue: 'His misery touches our soul, but we would wish to be able to bear misery like this great man.' Etty invents another occasion of his vanquished warrior's suffering. He also breaks down the stage convention whereby the audience is passive witness to events. In an age of sensibility, the drama would have been emotionally too spare if only the wrath of the victor and the despair of the vanquished comprised the action. Etty introduces the woman, as the proxy of the audience, acknowledging pity and the desire to intercede as the emotional consequences of the action, on the other side of the footlights, so-to-speak.

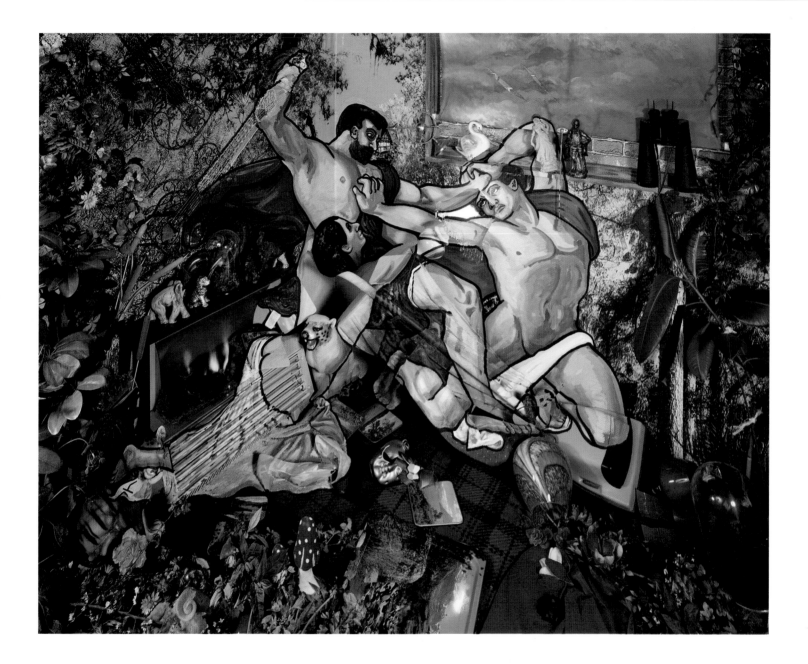

· 3 ·

PHILOCTETES LEFT ON THE ISLE OF LEMNOS BY THE GREEKS

AFTER DAVID SCOTT

DAVID SCOTT 1806–49

Philoctetes Left on the Isle of Lemnos by the Greeks on their Passage towards Troy
Oil on canvas · 101 × 119.4cm · National Gallery of Scotland

The story of Philoctetes, in the *Iliad* and in the play by Sophocles, stands in dramatic-ironic counterpoint to that of Laocoön. The Greek warrior is the inheritor of the bow and arrow of Hercules. He encourages the Greek fleet to land on the island of Lemnos in order to perform propitiatory sacrifices. He is bitten by a snake and his groans of pain are so loathsome to the Greeks that he is abandoned on the island. Later, it will be necessary for him to be rescued, for a seer reveals that without the weapons of Hercules, Troy will not be taken by the Greeks.

David Scott has chosen to show the moment of double agony in the figure of Philoctetes, who, again, as a figure, derives from *The Laocoön*. It is a dreadful torture, to be abandoned and to be left with the pain of one's wound. To be in hell or prison could be like this, for they are deaf places. Scott has chosen to deviate from the story or to eleborate it in an important particular, and in doing so makes his contribution to the debate about nobility in suffering. Suffering had to be mute. The pain of abandonment added to that of his wound makes for greatness in Philoctetes' suffering, and his cries cease.

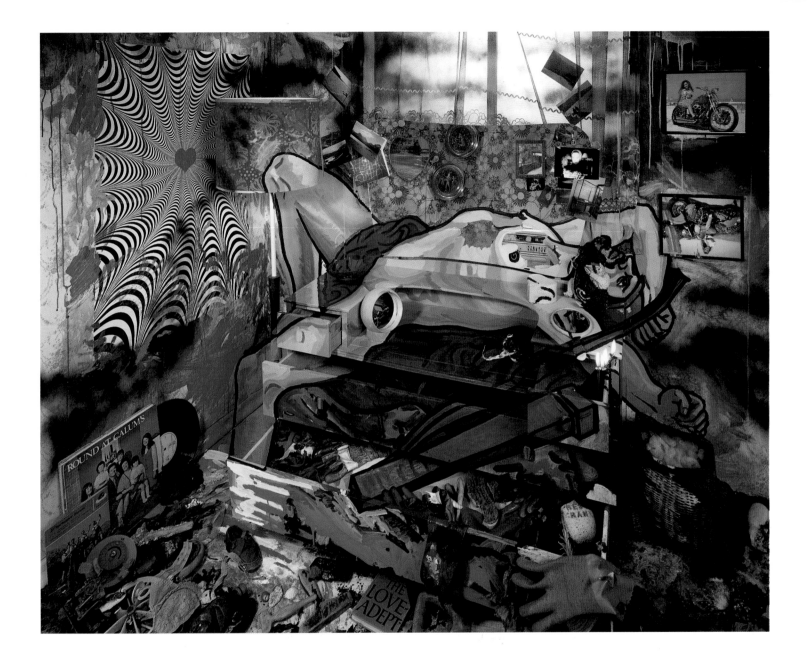

· 4 ·

THE STONING OF ST STEPHEN

AFTER ELSHEIMER

ADAM ELSHEIMER 1578–1610
The Stoning of St Stephen c.1602–5
Oil on copper · 34.7 × 28.6cm · National Gallery of Scotland

St Stephen was the first Christian martyr. Four figures perform the
stoning before a multitude of witnesses. Among them is the young
Saul, later St Paul, in shadow lower right, 'consenting unto his
death'(Acts 8:1). On the point of death, Stephen is rewarded by the
arrival of an angel and cherubs in glory, delivering the palm of victory
over death that goes to martyrs. It is the nature of miracles that the
world of matter is obliged to defer to the realm that is without mat-
ter. The point is made explicit here by the diagonal shaft of light which
journeys down past the flesh of the proto-martyr to the tumble of
stones bottom right. The assassins' stones – that have come from the
fabric of the ruinous monuments to Roman triumph in Jerusalem –
attempt the victory; but it goes to the light.

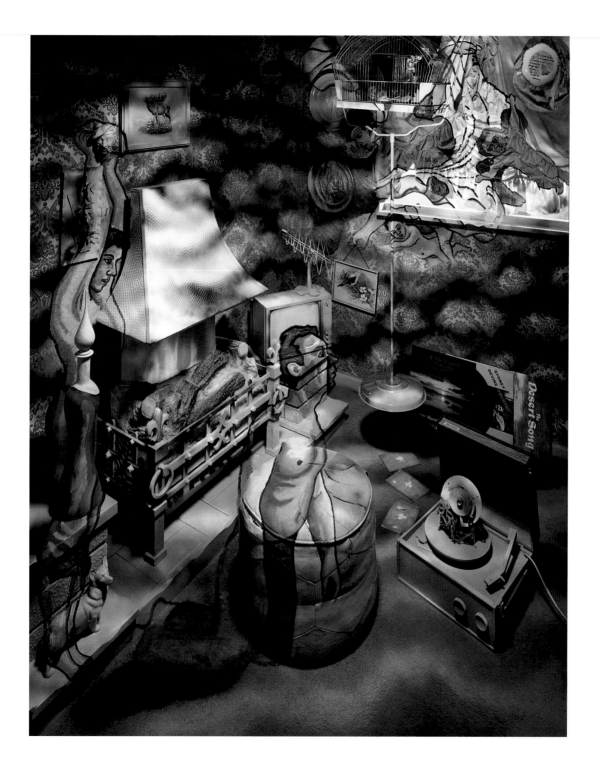

♠ 5 ♠

THE FEAST OF HEROD

AFTER PETER PAUL RUBENS

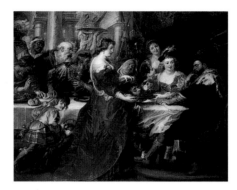

PETER PAUL RUBENS 1577–1640
The Feast of Herod
Oil on canvas · 208 × 264cm · National Gallery of Scotland

John the Baptist's has been an ascetic voice at the luxurious court of Herod (Mark 6). He has denounced the lubricity of Herodias, the king's mistress, to the left of Herod. Her opportunity to revenge herself upon him comes when her daughter, Salome, has inflamed Herod's sexual appetite by her dance. He offers her anything as reward. Herodias persuades Salome to ask for the head of John the Baptist.

Rubens interprets the story in terms of cannibalism. The picture reads from left to right, parallel to the picture plane. Following craned necks and glances, and the page boy with bells and a monkey, all going to the right, the observer progressively expands his understanding that a banquet is in progress. The earlier courses have been served. Anticipation and appetite are raised to the maximum degree at the luscious figure and red dress of Salome. Then Rubens presents the main course. It makes the stomach rebel. And Herod recoils in horror and revulsion. However, Herodias prods the Baptist's tongue with a fork and suggests that the king might savour the tasty morsel. This, when at her elbow is a plump and porcine priest who would make much better eating than the raw, scrawny and unshaven dish.

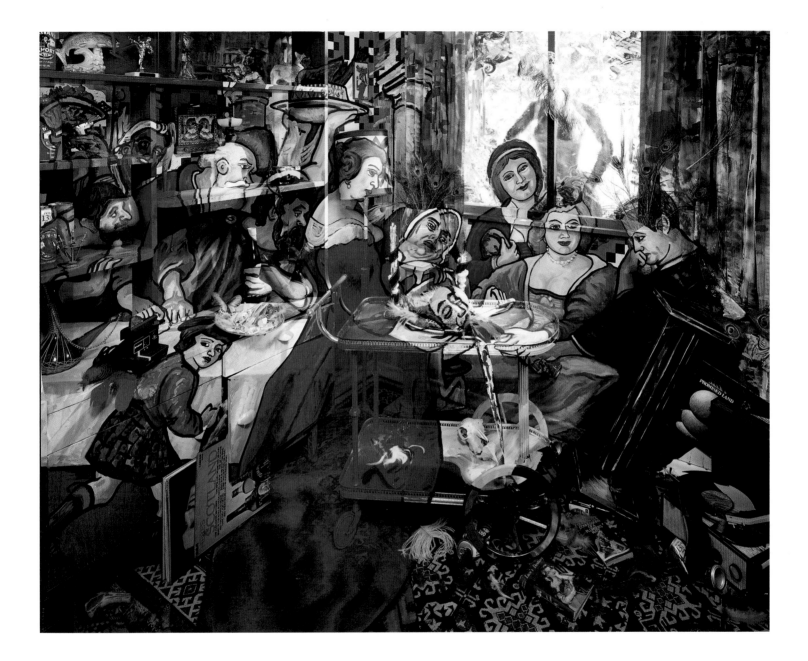

♦ 6 ♦
DIANA & ACTÆON
AFTER TITIAN

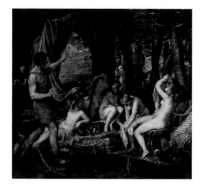

TIZIANO VECELLIO [TITIAN] *c.*1473/90–1576
Diana and Actæon
Oil on canvas · 184.5 × 202.2cm · National Gallery of Scotland (Duke of Sutherland Loan)

The story is of metamorphosis. Titian has based his treatment largely on Ovid's telling of the tale of the hunter Actæon, who comes upon Diana, the huntress, virgin goddess of the moon, with her nymphs in her secret glade. This is a sacrilegious intrusion by Actæon. Diana punishes him by turning him into a stag, who will be pursued to his death by his own hounds.

Titian has taken up the challenge of the story for the visual artist. This is that Actæon's sin is seeing, and that seeing is essentially remote from its object. A centrifugal force must therefore operate within the composition. Actually, Actæon's *punishment* is also seeing, for he knows his fate and tries to shield his vision from the deer's skull on the pillar. It may be too that Actæon has seen only the reflection of Diana in the water of the sacred pool and that Diana kicks water upon him to shatter the mirror and perform the transformation of hunter into hunted.

It is hubristic to demand, like Actæon, to see and know everything. In life, knowledge might be denied because the world beyond the individual might insist upon not being merely an object of knowledge. The nineteenth-century painter Manet thought in these terms, and what Actæon experiences – a cold greeting, a black maid and the attention of an unfriendy pet animal – are the subject of his picture, *Olympia*.

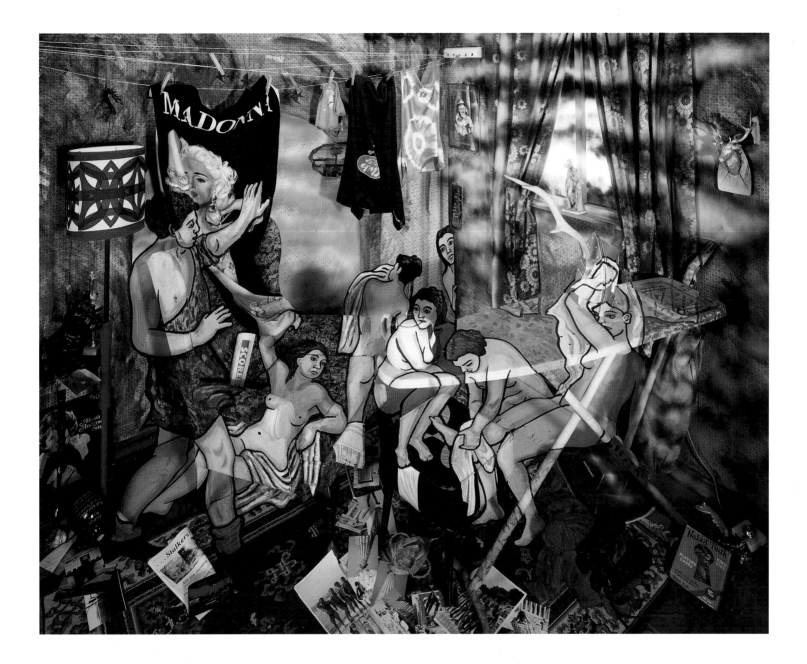

♦ 7 ♦

DIANA & CALLISTO
AFTER TITIAN

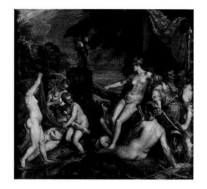

TIZIANO VECELLIO [TITIAN] *c.*1473/90–1576
Diana and Callisto
Oil on canvas · 187 × 204cm · National Gallery of Scotland (Duke of Sutherland Loan)

Diana and Callisto is pendant to *Diana and Actæon*. Both were part of a commission for *Poesie* – pictures often with mythological allusions dealing with imponderables – for Philip II of Spain.

Callisto has been raped by Jupiter, in disguise as Diana. Her pregnant condition is revealed to Diana, when Callisto shows reluctance to bathe naked in a stream; and Diana casts out the nymph whose virginity has been breached. Callisto will wander the wild wood, transformed into a bear by Juno, until Jupiter intervenes to prevent her from being shot by her son Arcas and transports them both into heaven where they are turned into constellations.

The covering or disclosing of nakedness is a theme of both pictures. Whereas Actæon penetrates a secret, revelation happens by the agency of the nymphs in *Diana and Callisto*. The nymphs in *Diana and Actæon* disperse as, in their different ways, they attempt to hide their nakedness. The conspiracy of the nymphs to reveal Callisto's secret brings them together into a tight compositional grouping. With Actæon and the standing nymph in *Diana and Callisto* being interchangeable, the three nymphs to the left in both pictures could also interchange actions without much difficulty.

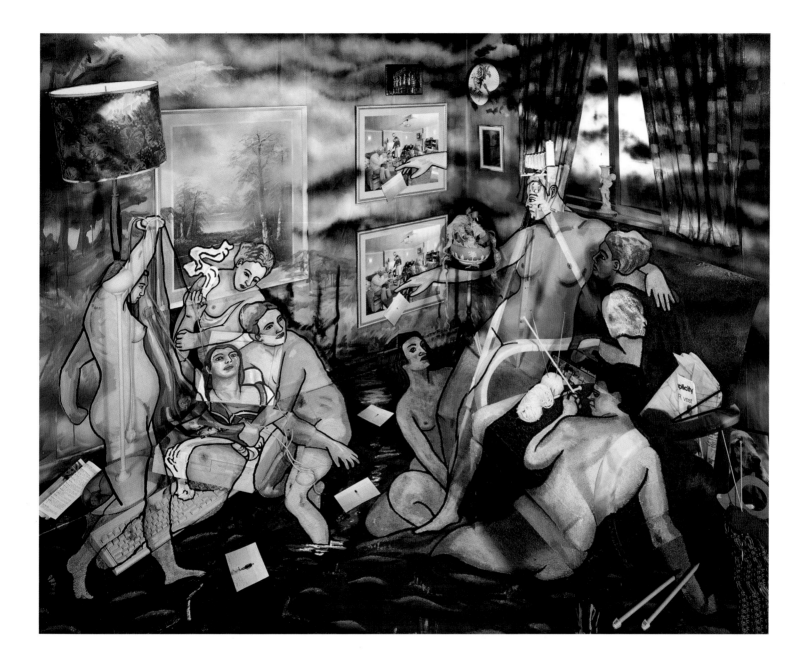

❧ 8 ❧
VENUS ANADYOMENE
AFTER TITIAN

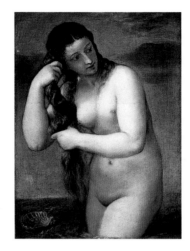

TIZIANO VECELLIO [TITIAN] *c.*1473/90–1576
Venus Anadyomene
Oil on canvas · 75.8 × 57.6cm · National Gallery of Scotland (Duke of Sutherland Loan)

Venus' association with water connects with a particular story of her genesis and a theory of genesis itself. In a sense, she is the sister of time. Cronos, the son of Heaven and Earth (Uranus and Gaia), castrated his father, presumeably in order to bring to a halt the creation of celestial gods of whom he would be in envy because of his dual nature, and consigned Uranus' parts to the intermediate element, water. It is easy to imagine what scientists have more recently called a 'primordial soup', a fluid with a genetic potentiality in it. Venus was the offspring of the seed of Uranus and the element, water – a sort of *in vitro* fertilisation.

She is shown here rising out of the sea. She wrings out her hair. Inclining her body forward, Venus is not aloof, but has a certain complaisance. It is impossible for human beings to approach a true imitation of Juno or Minerva, but they may imitate Venus in good faith.

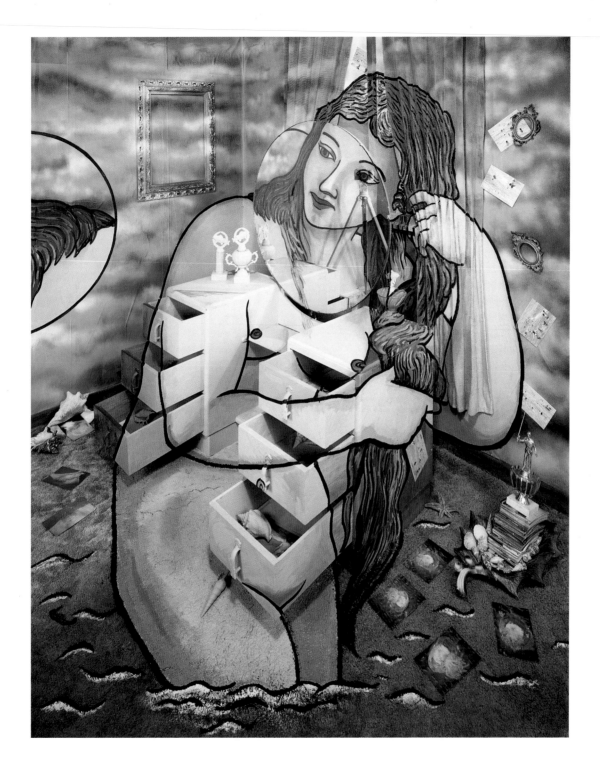

CALUM COLVIN

Born, Glasgow 1961

1979–83 Duncan of Jordanstone College of Art, Dundee
Diploma in Sculpture

1983–5 Royal College of Art, London
MA in Photography

1997 The 13th Higashikawa Overseas Photographer Prize

1995–6 Research Fellow in Digital Imaging,
University of Northumbria

Currently Lecturer in Fine Art at Duncan of Jordanstone,
University of Dundee

SELECTED INDIVIDUAL EXHIBITIONS

1989 California State University, Long Beach, California

Friedman-Guinness Gallery, Frankfurt

Salama Caro Gallery, London

Pier Arts Centre, Stromness, Orkney

Harris Museum and Art Gallery, Preston

Portfolio Gallery, Edinburgh

1990 'Brief Encounter', Fruitmarket Gallery, Edinburgh

Haggerty Museum, Milwaukee, Wisconsin

Glenn / Dash Gallery, Los Angeles

Torch Gallery, Amsterdam

Aberdeen Art Gallery

1991 'The Two Ways of Life', Art Institute of Chicago

Salama Caro Gallery, London

1992	San Francisco Museum of Modern Art
	Nickle Arts Museum, Calgary
	Winnipeg Art Gallery.
1993	'The Seven Deadly Sins and the Four Last Things', Portfolio Gallery, Edinburgh
	Badischer Kunstverein, Karlsruhe
	Photographers Gallery, London
	Photosynkyria, Thessalonki, Greece
1994	Norwich Arts Centre
	BM Contemporary Art Center, Istanbul
	Banco Central Art Gallery, Quenca, Ecuador
	British Council, Quito, Ecuador
	Royal Photographic Society, Bath
	Seagate Gallery, Dundee
	Photography Centre of Athens
1995	'Unlikely Stories', Kulturhuset, Stockholm
	Photographic Museum of Finland, Helsinki
1996	'Ornithology', Jason and Rhodes Gallery, London
	'Pseudologica Fantastica', Impressions Gallery, York
1997	Focal Point Gallery, Southend-on-Sea
	Portfolio Gallery, Edinburgh
	Theatr Clwyd, Mold, Wales
1998	Primavera Festival, Barcelona
	University of Salamanca
	Columbus State University, Columbus, Georgia

1987 'The Vigorous Imagination: New Scottish Art', Scottish National Gallery of Modern Art, Edinburgh

1989 'Through the Looking Glass, Photographic Art in Britain 1945–89', Barbican Art Gallery, London

 'Towards a Bigger Picture', Victoria & Albert Museum, London

 'Machine Dreams', Photographers Gallery, London

 'Das Konstruierte Bild', Kunstverein, Munich

1990 Fotofest, Houston

 'New Scottish Photography', Scottish National Portrait Gallery, Edinburgh

 'Photography on Site' (Calum Colvin + Ron O'Donnell), California State University, California

1991 'DeComposition', Chapter Arts Centre, Cardiff

1992 'A Decade of Fine Art', Dundee Museum

 'Addressing the Forbidden', Art Gallery, Brighton Polytechnic

 'La Photographie Britannique', Arles

1993 Portfolio Gallery, Edinburgh

1994 'An American Passion' McLellan Galleries, Glasgow

 'Elvis + Marilyn: 2 × Immortal', Institute of Contemporary Art, Boston

 'Revisions', Kulturreferat der Landeshaupstadt, Munich

1995 'Light from the Dark Room', Royal Scottish Academy, Edinburgh

1996 'Photography after Photography', Aktionsforum Praterinsel, Munich

1997	'Body Politic', Wolverhampton Art Gallery and Derby Art Gallery
1997	'History: the Mag Collection', Ferens Museum, Hull; Fruitmarket Gallery, Edinburgh.

'On The Bright Side of Life – Contemporary British Photography', NGBK, Berlin; Kunstverein, Karlsruhe

COLLECTIONS

Aberdeen Art Gallery

Royal Photographic Society, Bath

Arnolfini Collection Trust, Bristol

Art Institute of Chicago

Dundee City Art Gallery

City Art Centre, Edinburgh

Scottish National Gallery of Modern Art, Edinburgh

Scottish National Portrait Gallery, Edinburgh

Scottish Arts Council, Edinburgh

Gallery of Modern Art, Glasgow

Museum of Fine Art, Houston

Ferens Museum, Hull

The British Council, London

Contemporary Art Society, London

Victoria and Albert Museum, London

The Metropolitan Museum of Art, New York

Harris Museum and Art Gallery, Preston

SELECTED BIBLIOGRAPHY

1987 *The Vigorous Imagination: New Scottish Art*, exhibition catalogue,
Keith Hartley, Clare Henry and Henry Meyric Hughes, National Galleries of Scotland,
Edinburgh

1989 *Through the Looking Glass*, exhibition catalogue, Sarah Kent, Barbican Art Gallery, London

1990 *Calum Colvin*, exhibition catalogue, David Alan Mellor, Fruitmarket Gallery, Edinburgh

New Scottish Photography, exhibition catalogue, David Brittain and Sara Stevenson,
National Galleries of Scotland, Edinburgh

Article in *Creative Camera* by James Lawson

1991 *The Two Ways of Life*, exhibition catalogue, Colin Westerbeck and David Alan Mellor,
Art Institute of Chicago

1993 *The Seven Deadly Sins and the Four Last Things*, exhibition catalogue, Tom Normand,
Portfolio Gallery, Edinburgh

Scottish Painting, Bill Hare, Talbot Rice Gallery, Edinburgh

The Two Ways of Life and Other Photographic Works, exhibition catalogue, Dr Andreas
Vowinckel, Badischer Kunstverein, Karlsruhe

1994 *Revisions*, Ulrich Pohlmann, Sara Stevenson, James Lawson, Nazraeli Press, Munich

Article in *Portfolio,* no.17, by James Lawson, Portfolio Gallery, Edinburgh

1995 *Light from the Dark Room*, exhibition catalogue, National Galleries of Scotland,
Edinburgh

Transcript no.1, interview with Tom Normand, Duncan of Jordanstone College, Dundee

1996 *Photography after Photography*, exhibition catalogue, Alexis Cassel, G + B Arts, Munich

Article in *Portfolio*, no. 24, David Alan Mellor, Portfolio Gallery, Edinburgh

On the Bright Side of Life, exhibition catalogue, David Alan Mellor, NGBK, Berlin

1997 *Story of Photography*, Michael Langford, Focal Press, Oxford